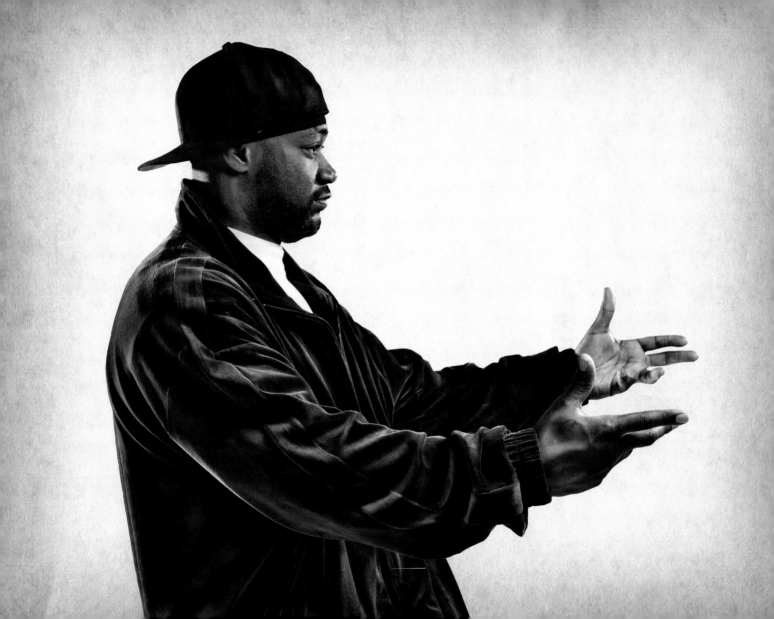

The World According To

PRETTY TONEY

by Ghostface Killah with J. Brightly

PHOTOGRAPHY BY DAVE HILL

MTV PRESS

Editor:
JODI LAHAYE

Photography:
DAVE HILL

Book design:
GABRIEL KUO

First published in the United States Of America in 2007 by MTV Press
A Division of MTV Networks
1515 Broadway
New York NY 10036

Distributed by powerHouse Books
37 Main Street, Brooklyn NY 11201 | PH 212 604 9074

First Edition
December 2007 / 10 9 8 7 6 5 4 3 2 1
Printed and Bound in China
ISBN: 978-1-57687-411-0
Library of Congress Control Number: 2007930429

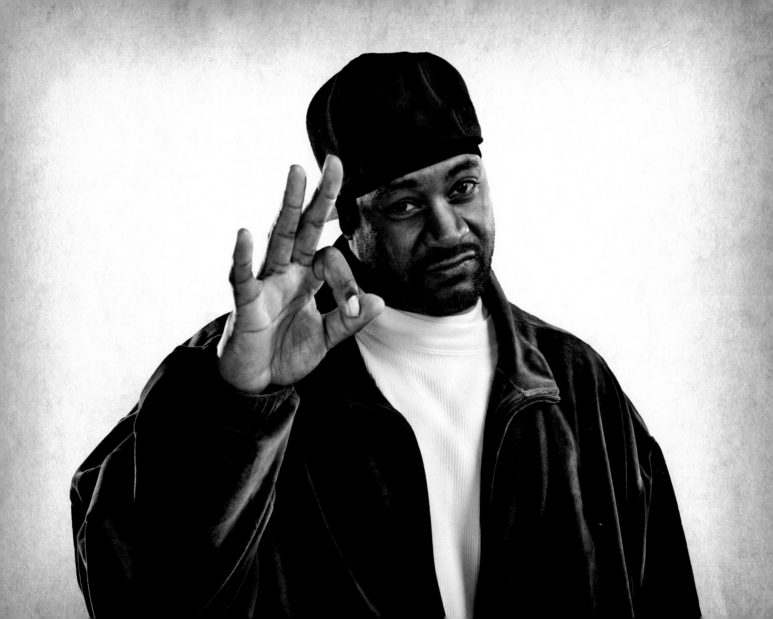

CONTENTS

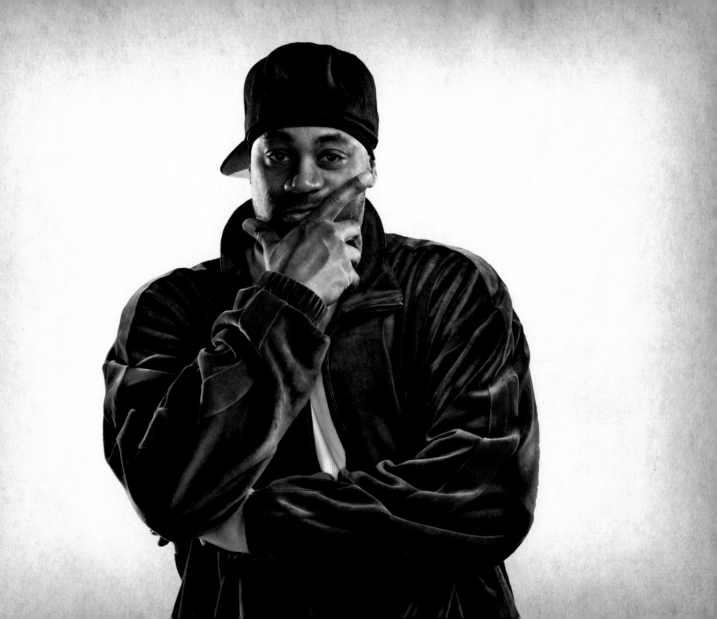

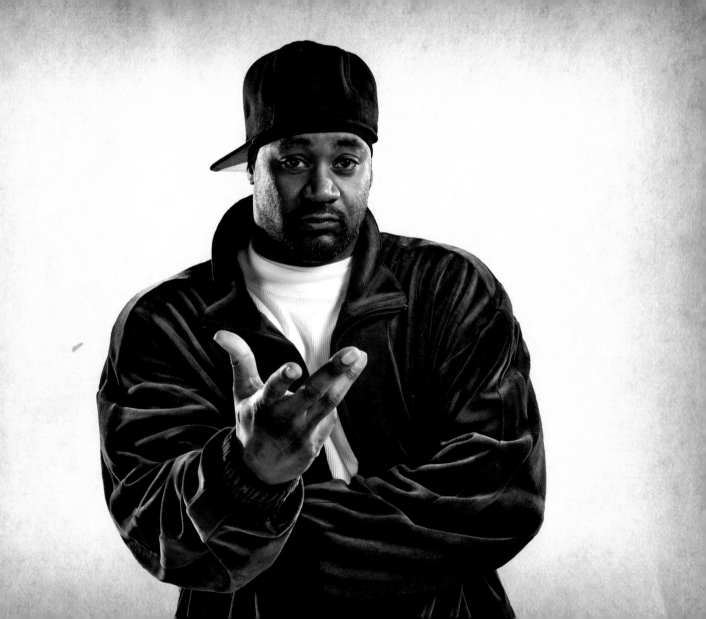

The World According To

Pretty Toney

LIVIN'

This chapter right here is on some real shit, son.
This is strictly on some everyday livin' because a lot of y'all ain't
livin' well or swell, so it's time to wisen up. Pay attention, G.

WAKE UP! IT'S TOO LATE IN THE GAME TO BE WALKING AROUND STUPID.

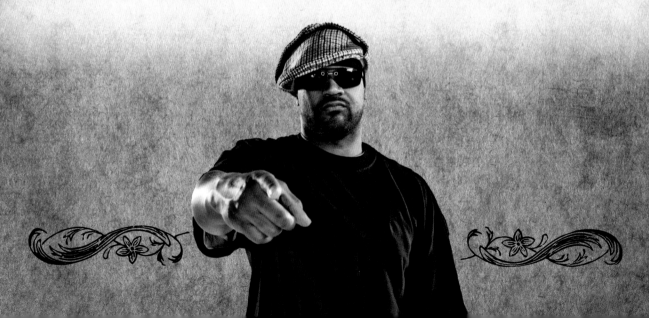

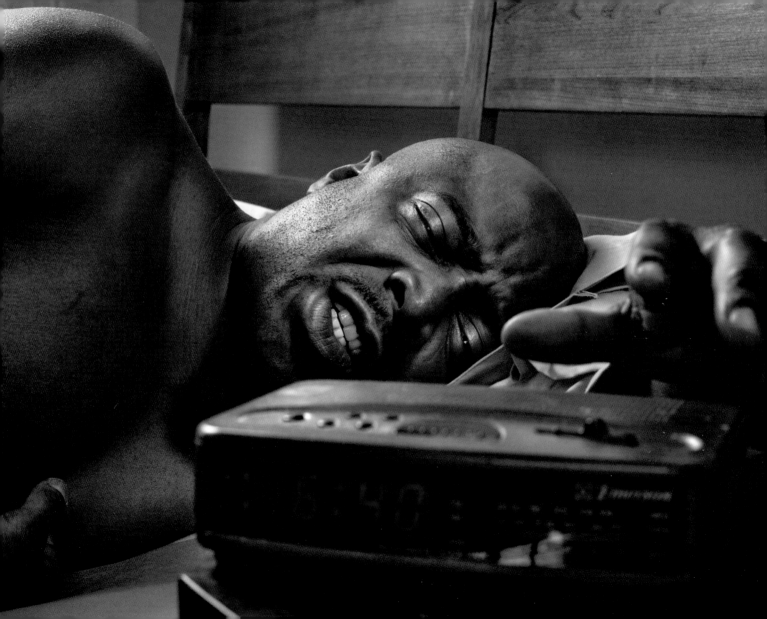

Pretty Toney says

MAKE SURE YOU GET THAT BULLSHIT OUT OF YOUR EYES.

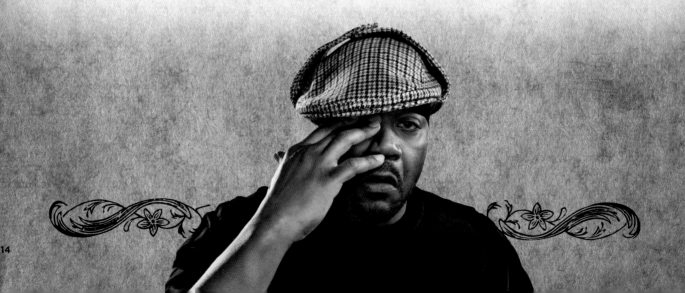

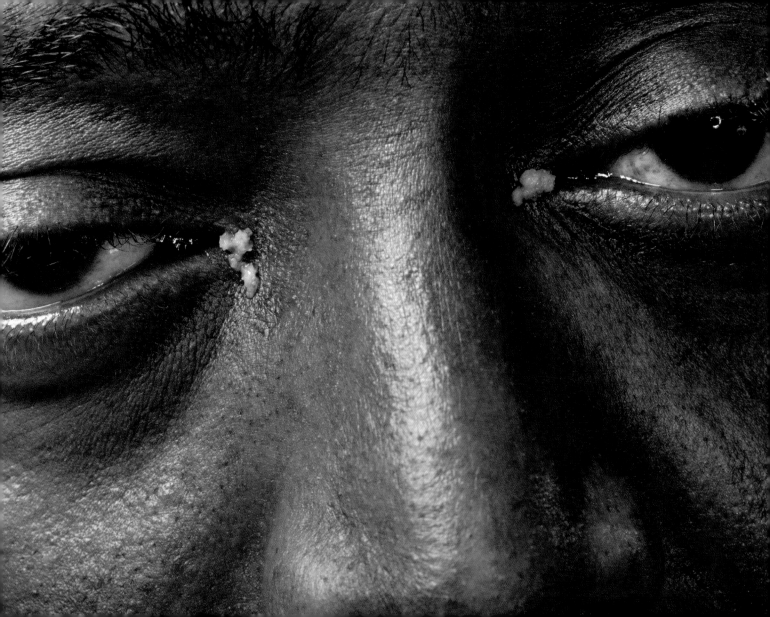

Pretty Toney says

BRUSH YOUR TONGUE, SON. THAT'S WHERE YOUR STINK BREATH IS HIDING.

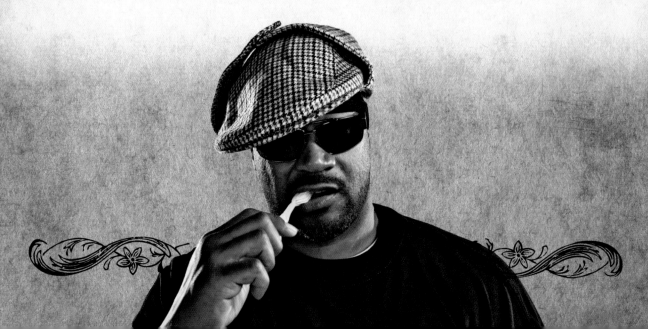

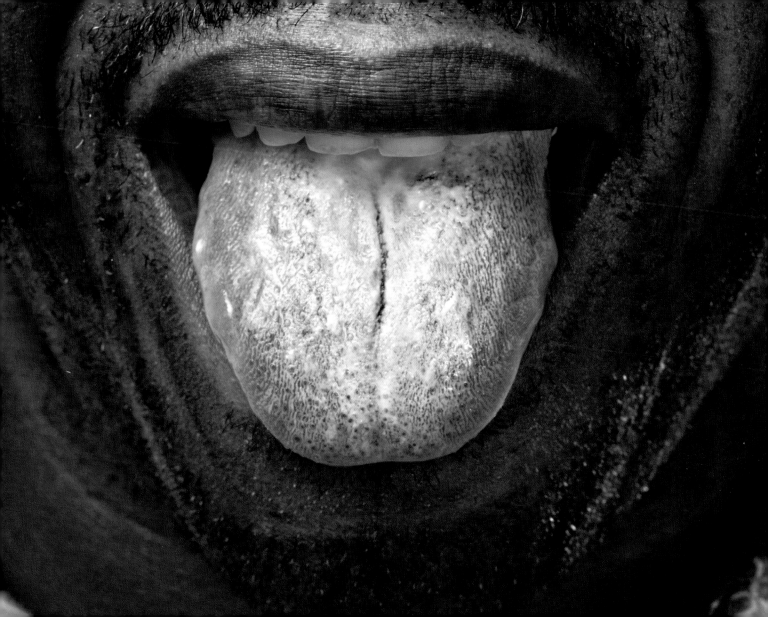

Pretty Toney says

LOSE THE BUMPS! USE HOT WATER WHEN YOU SHAVE TO AVOID LOOKING LIKE THE BACK OF A NESTLÉ CRUNCH BAR.

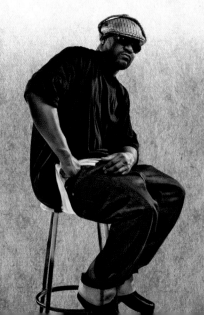

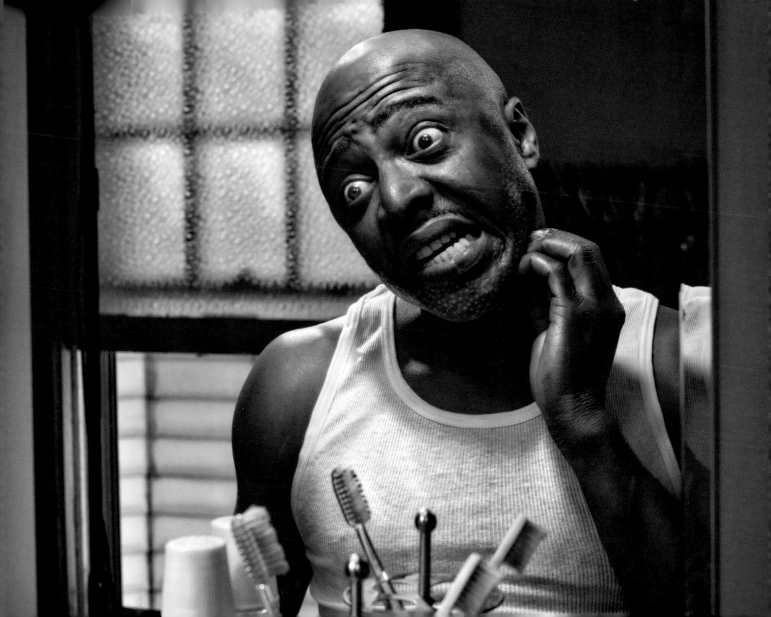

Pretty Toney says

REAL MEN TAKE SHOWERS! LEAVE THE BUBBLE BATHS TO THE LADIES.

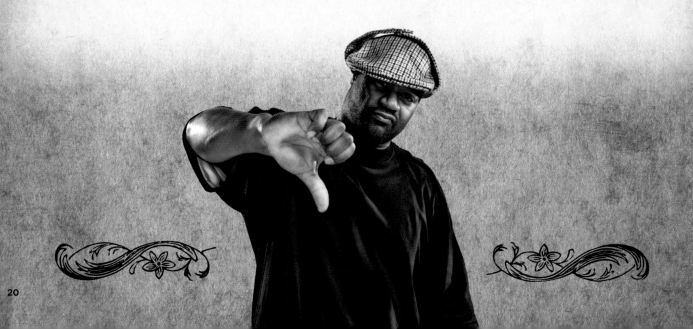

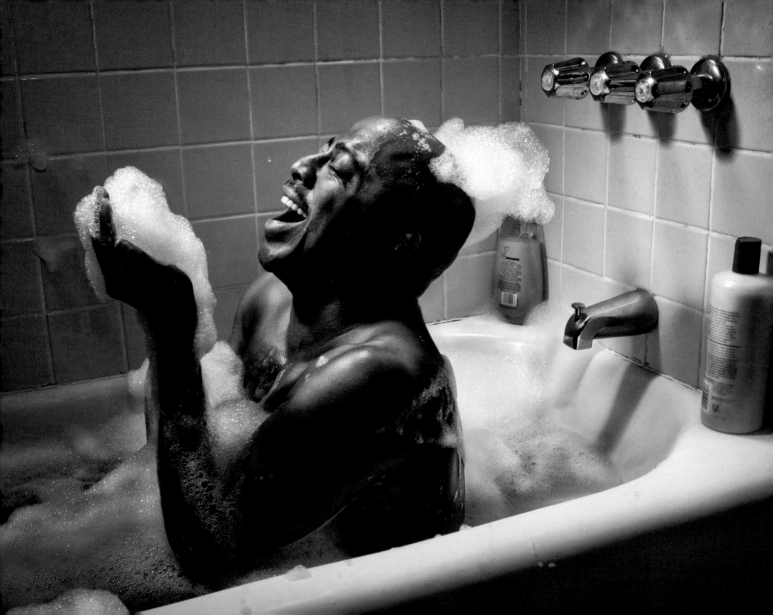

Pretty Toney says

TAKE A SHIT BEFORE YOU LEAVE THE HOUSE—NOTHING IS WORSE THAN HAVING TO DOO-DOO WHEN YOU HAVE IMPORTANT SHIT TO DO.

~ *THINGS THAT WILL MAKE YOU SHIT: Coffee, cocaine, whole milk, White Castle, collard greens.*

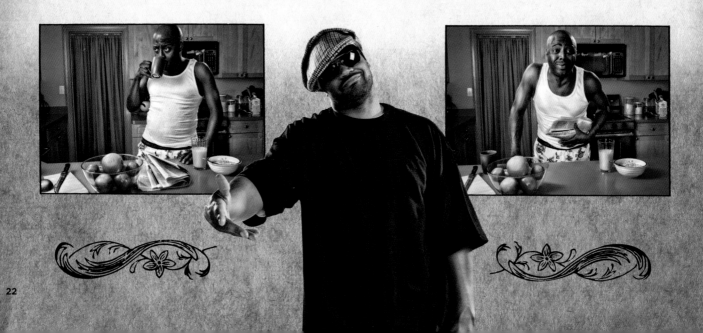

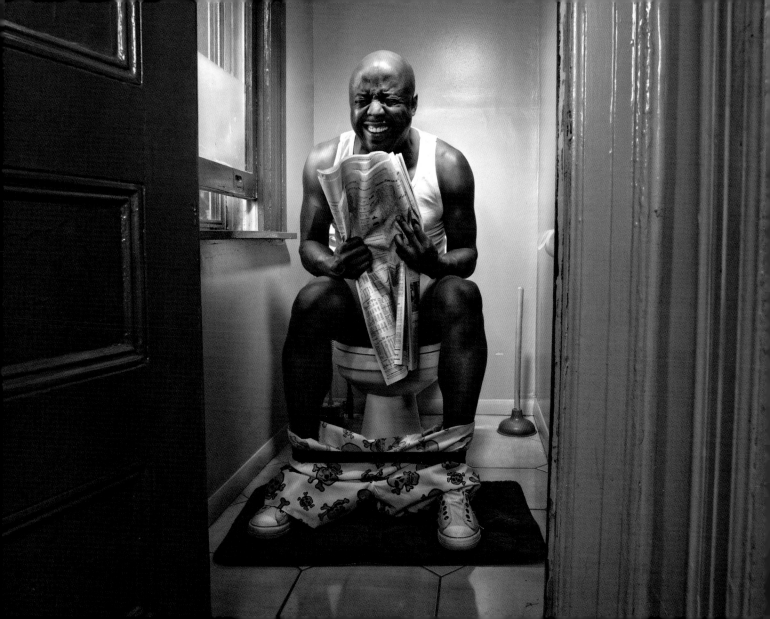

Pretty Toney says

WHEN YOU STEP OUT . . . STEP OUT RIGHT.

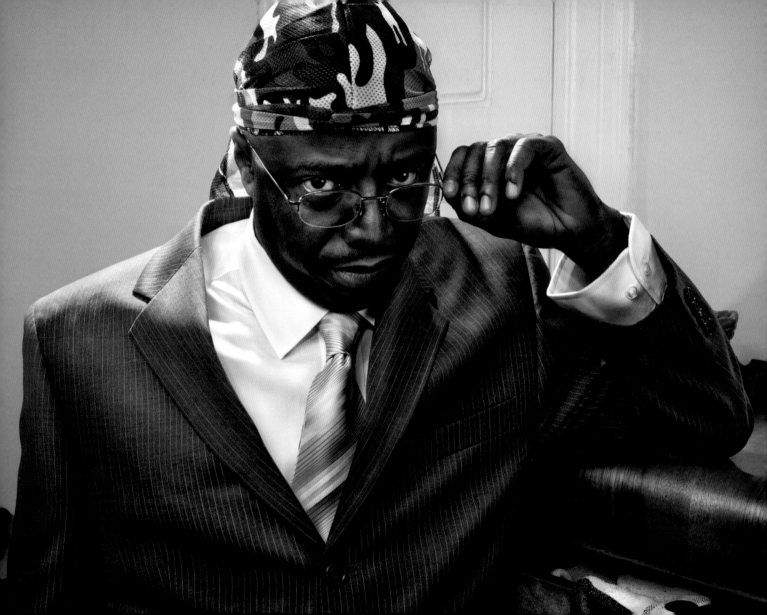

Pretty Toney says

DON'T ROCK CLOUDY JEWELS. PUT THAT SOURCE MAGAZINE SHIT DOWN.

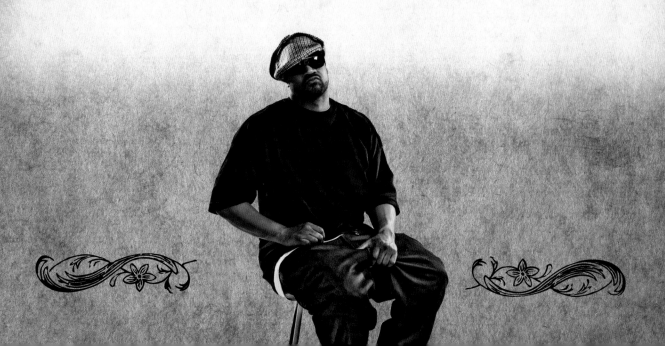

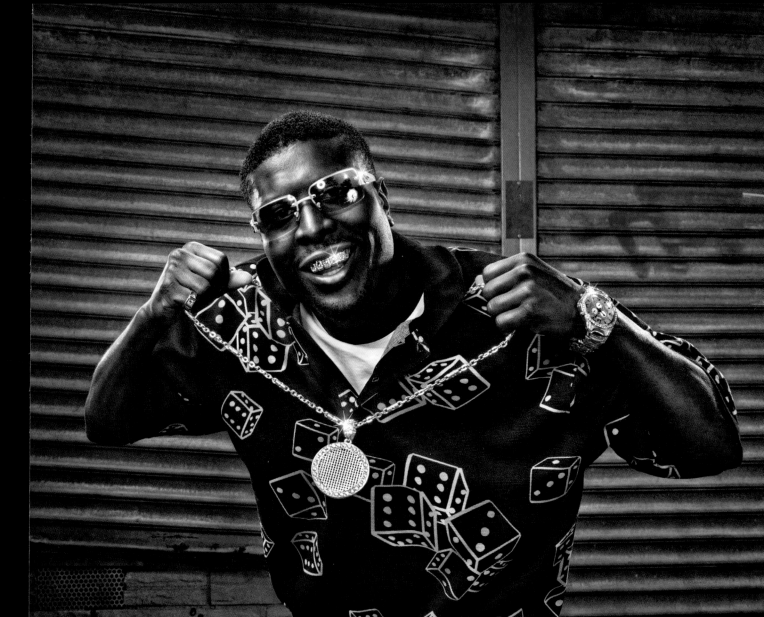

Pretty Toney says

DON'T ROCK CAPRI'S, G.

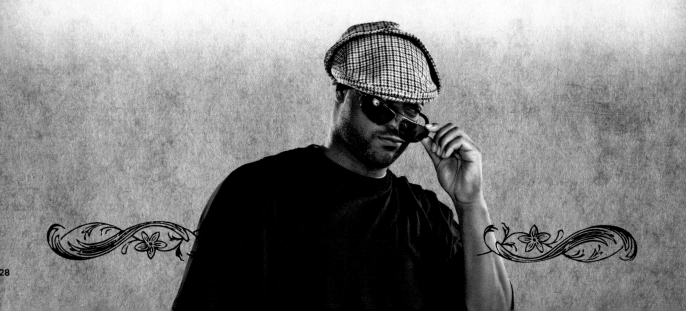

DON'T LET YOUR BOY GO OUT LIKE THAT.

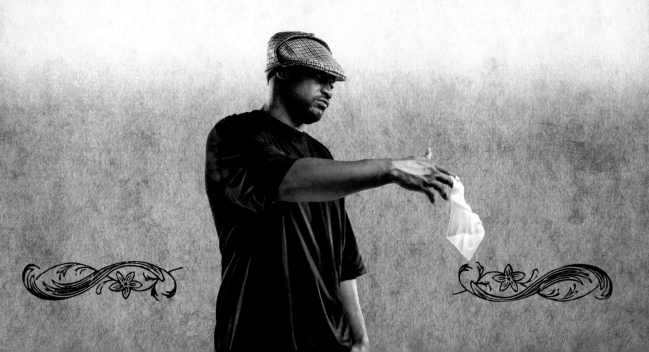

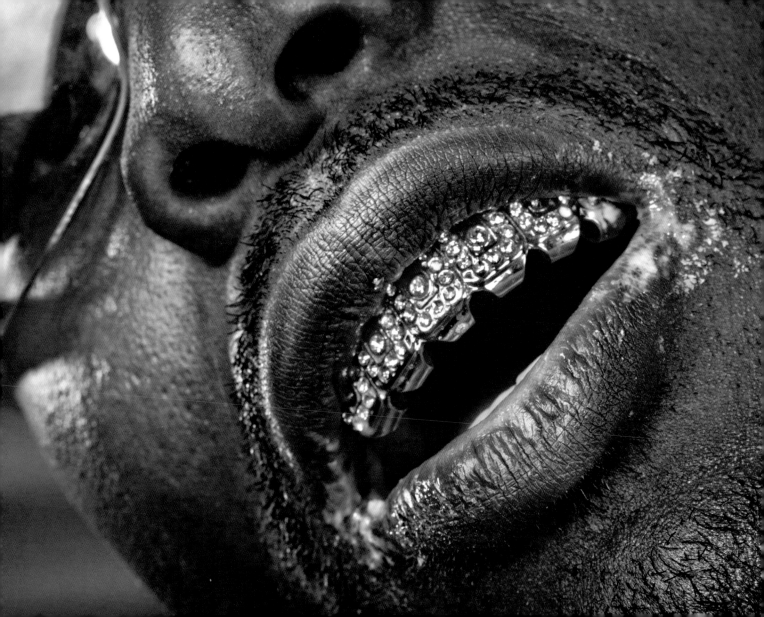

The World According To

Pretty Toney

BOBBIN' & WEAVIN'

Bobbin' and Weavin', that's how we do it in the streets, son.
You gotta stay on point cuz it's a fight everywhere you go.
Whether you bobbin' death, or weavin' from the cops, it's all survival.

Pretty Toney says

HOLD YOUR TONGUE AROUND FAKE NI$$AS.

~ "Ghostface Killah", 2nd verse, The Pretty Toney Album

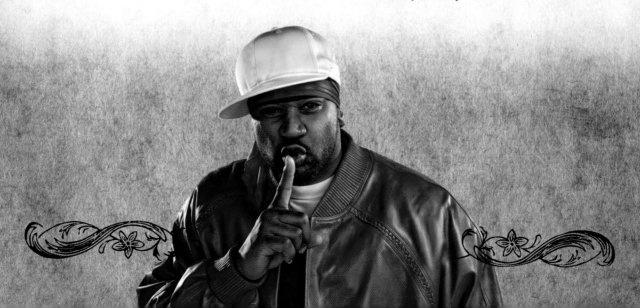

34

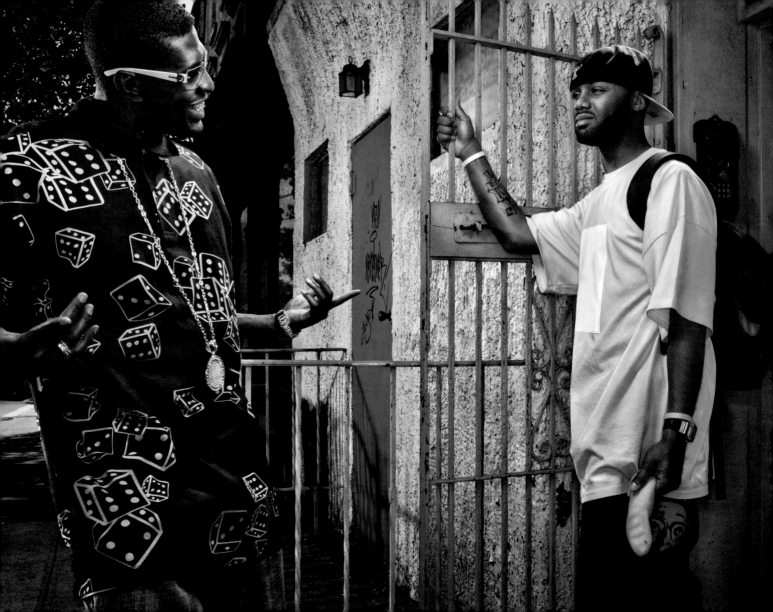

Pretty Toney says

IF YOU DON'T WANNA GET SNUFFED DON'T SNUFF NOBODY.

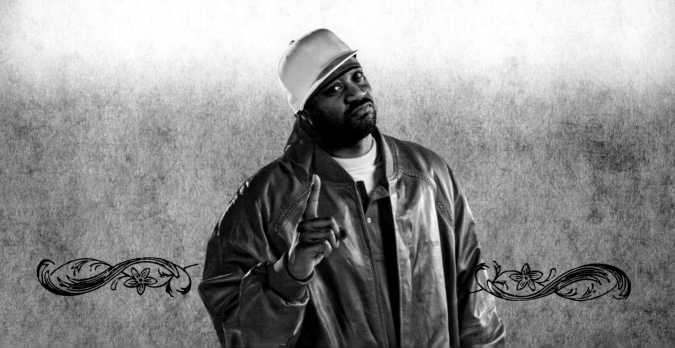

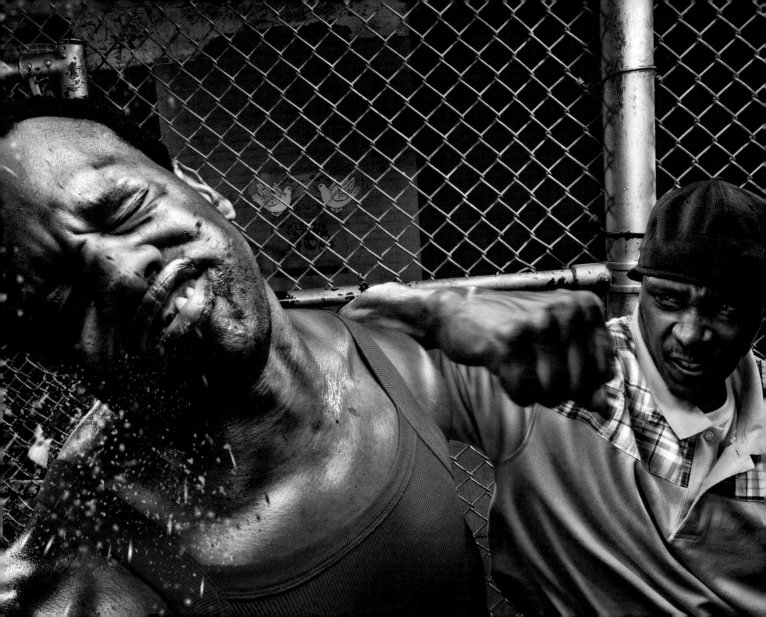

Pretty Toney says

BE NICE TO THE CRACKHEADS. SOMETIMES THEY'RE ALL YOU GOT.

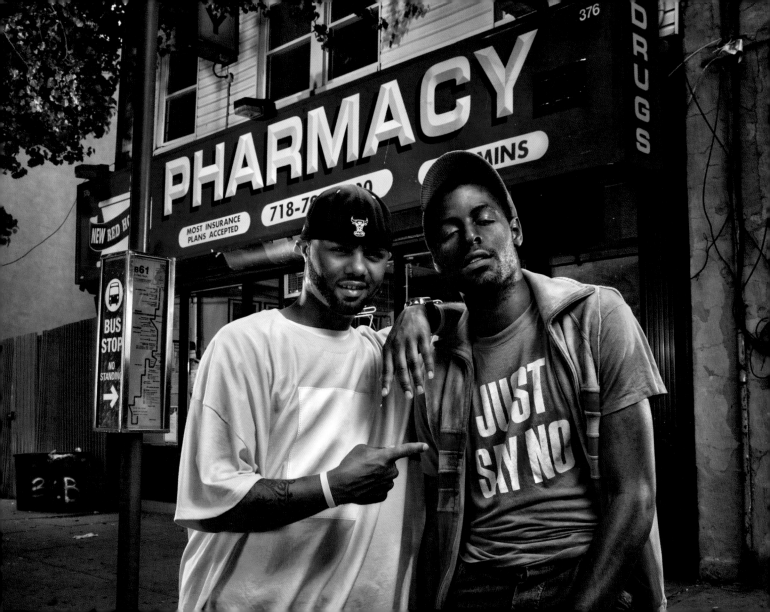

Pretty Toney says

DON'T LET YOUR BEEF STEW. HANDLE IT RIGHT AWAY OR YOU'LL END UP WATCHIN' OUT FOR PEEK-A-BOO MUTHERFUCKAS.

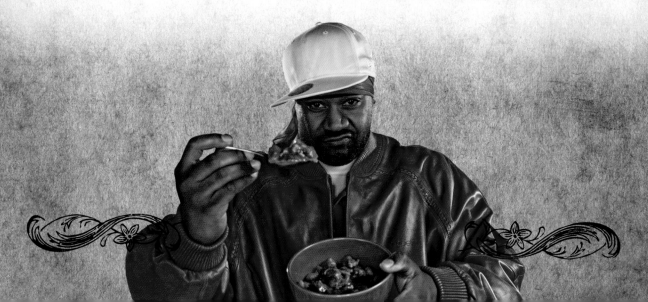

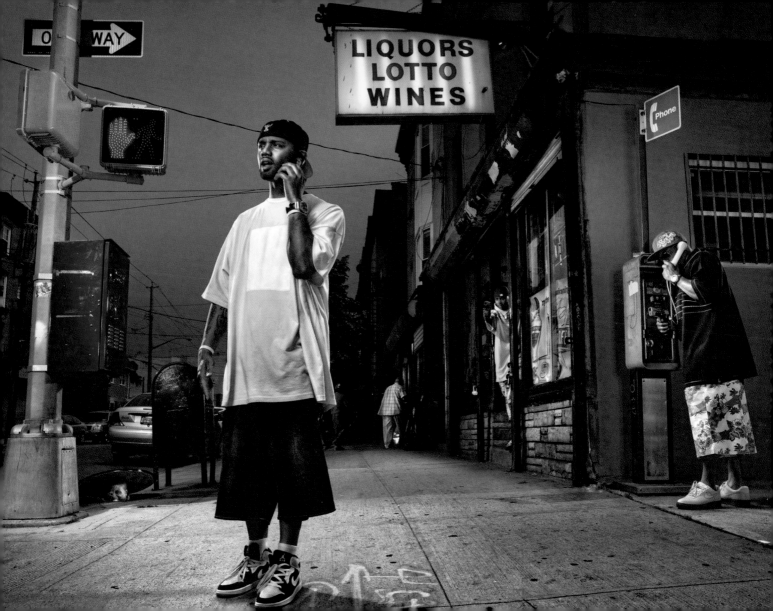

Pretty Toney says

DIVERSIFY! YOU GOTTA HAVE MAD HUSTLES. MAKE SURE TO HAVE PLAN B, C, D, E AND F READY TO GO.

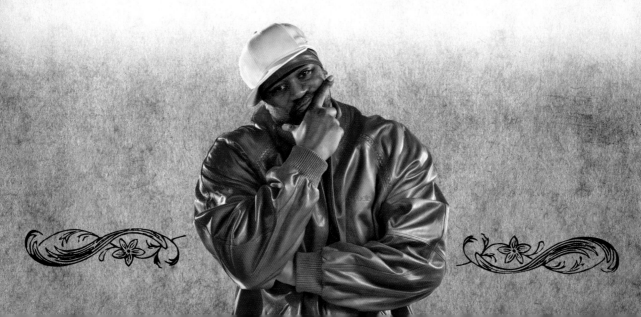

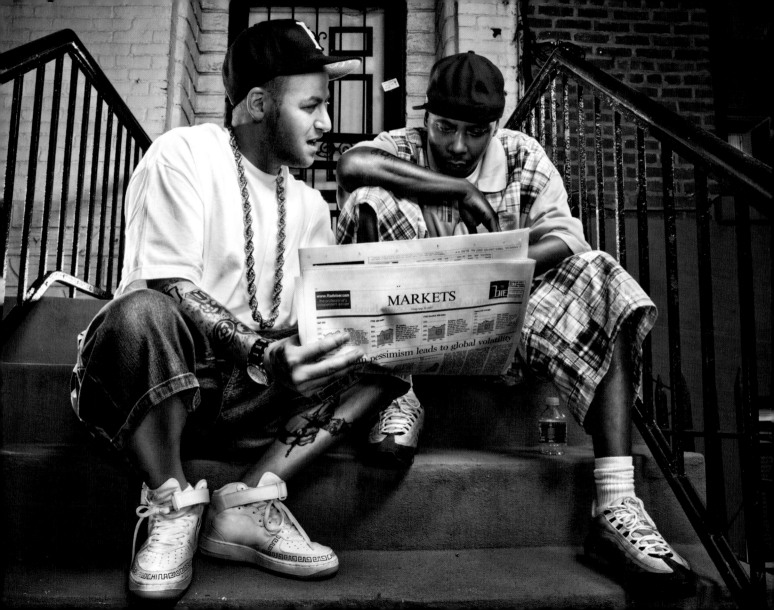

MARKETS

www.ftadvisor.com
the professor's
independent adviser

pessimism leads to global volatility

Pretty Toney says

FUCK THAT! RUN! COPS GOT GUNS!

~ *"Run", Chorus, The Pretty Toney Album*

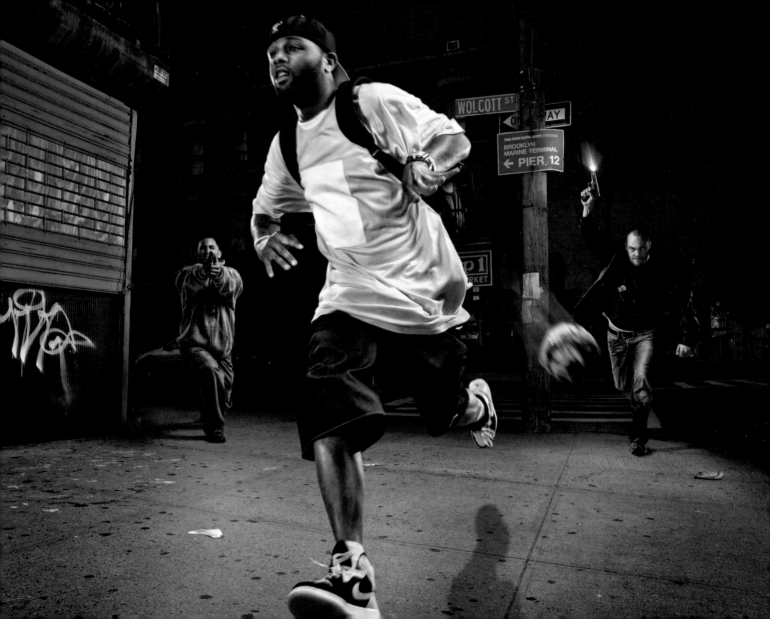

MAKE SURE YOUR BITE IS BIGGER THAN YOUR BARK, SON.

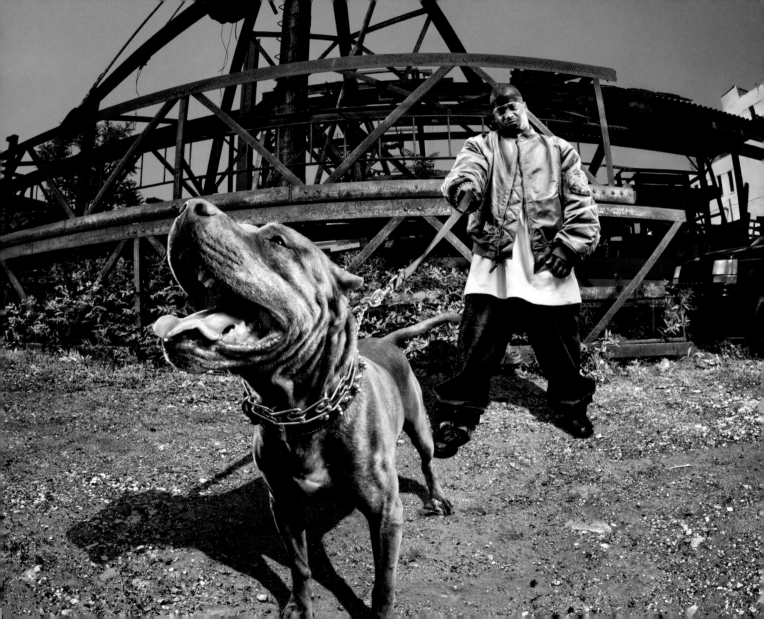

Pretty Toney says

A KILO IS A THOUSAND GRAMS, IT'S EASY TO REMEMBER.

~ *"Kilo", Chorus, Fishscale*

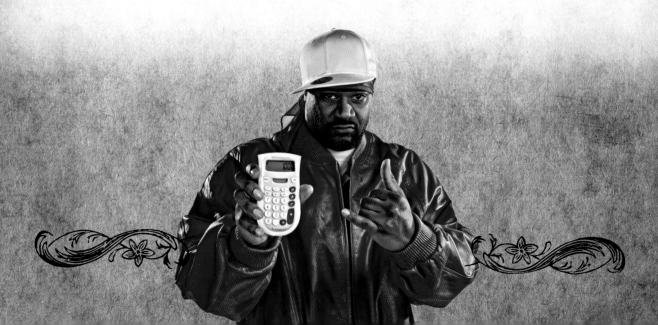

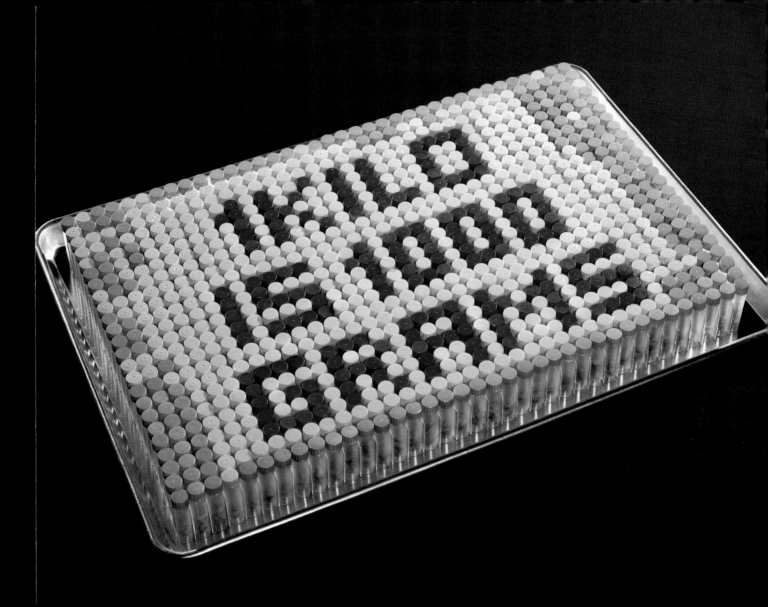

The World According To

Pretty Toney

WIZDOM

This section right here is about handling your wiz and shit.
There are a lot of places you can go wrong in a relationship, but follow these tips and she'll
do anything you say. If you don't take the advice I'm gonna show you how bad things could get.
Fallback and let's go into this world.

Pretty Toney says

SUFLAN (SOO-FLANE)

(sucker for love ass ni$$a)

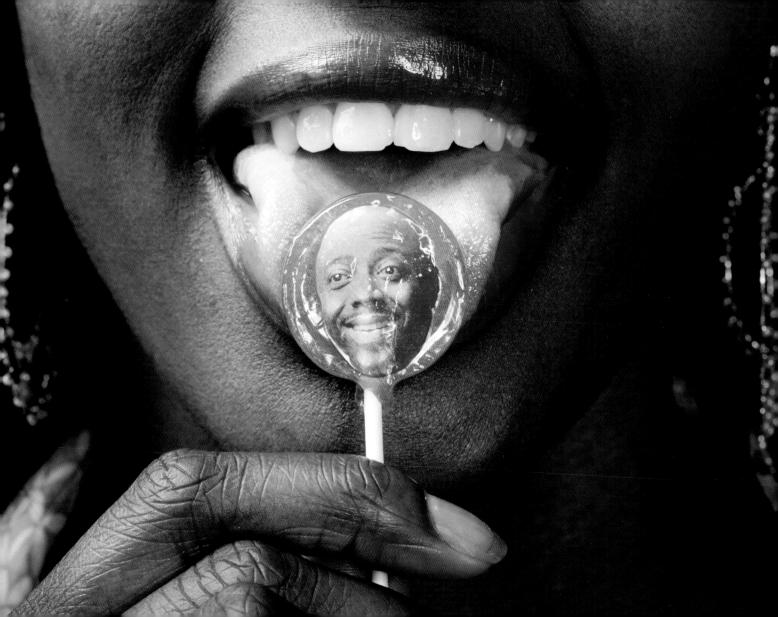

Pretty Toney says

PILLOW TALK IS A NO, NO. DON'T BE LAID UP RUNNING YOUR MOUTH.

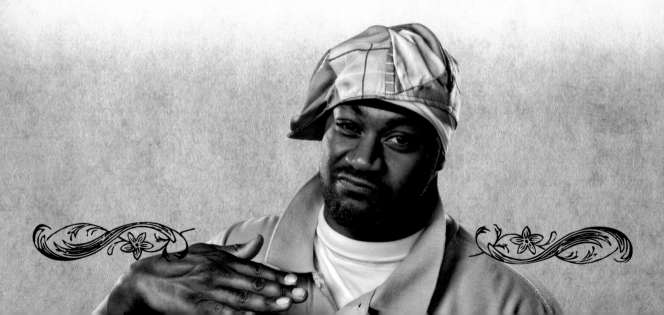

54

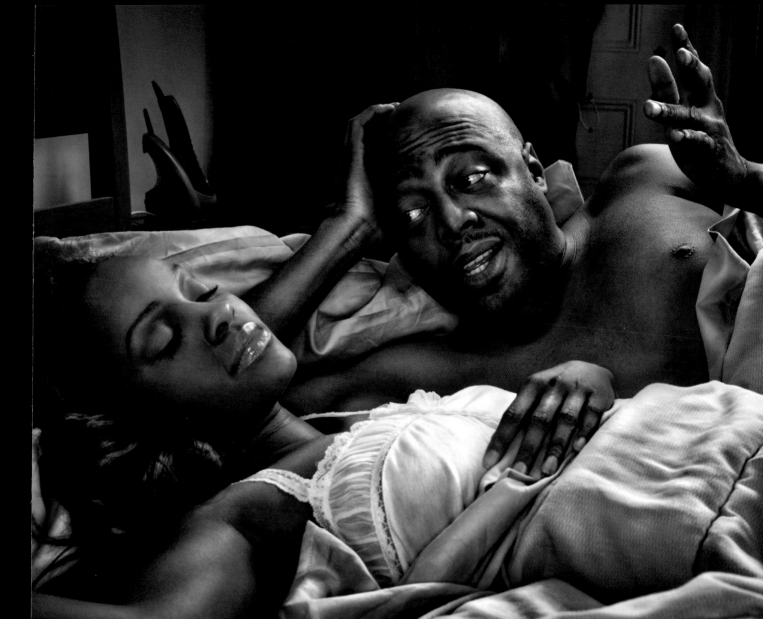

Pretty Toney says

SURVEY SAYS, YOUR WIZ MUST WAIT
AT LEAST 8 MONTHS BEFORE SHE
CAN TAKE A DUMP AT YOUR HOUSE.

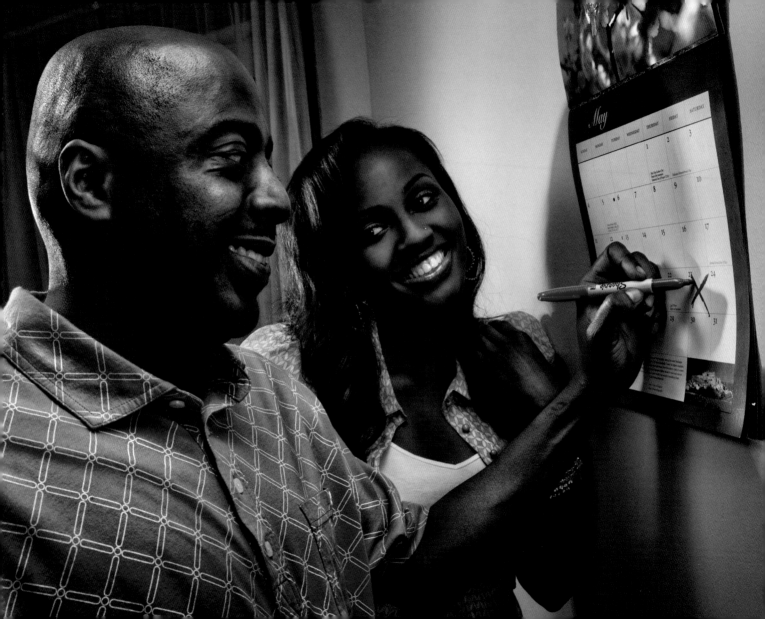

Pretty Toney says

THE SAME THING THAT'LL MAKE YOU LAUGH . . . CAN MAKE YOU CRY. IT IS POSSIBLE TO LIKE SOMETHING OR SOMEONE TOO MUCH.

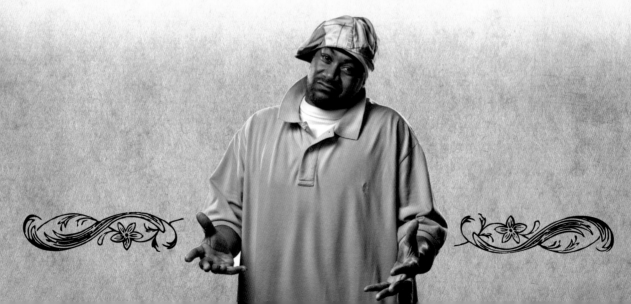

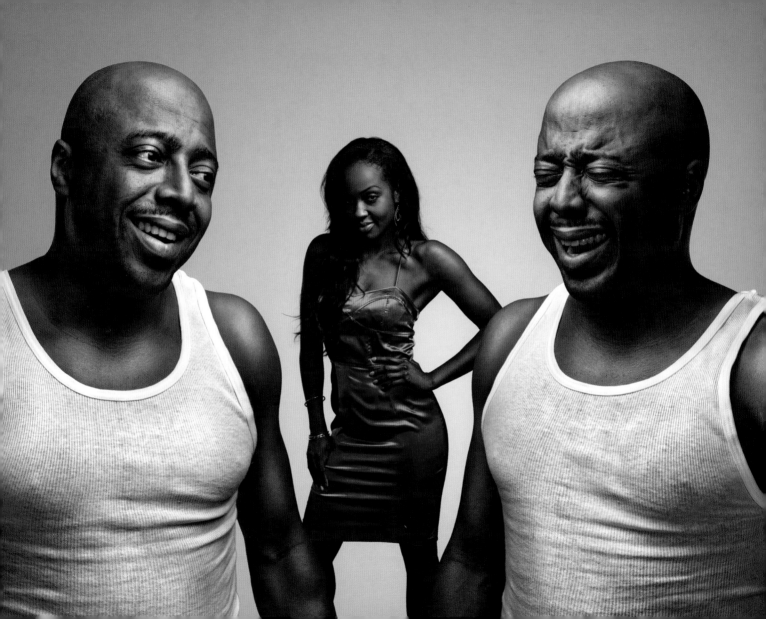

Pretty Toney says

STAY THE FUCK AWAY G. WHEN IT'S OVER, IT'S OVER, DON'T LET HER BREAK YOU DOWN TO THE POINT WHERE YOU MIGHT START SMOKING CRACK, OR COMMIT SUICIDE.

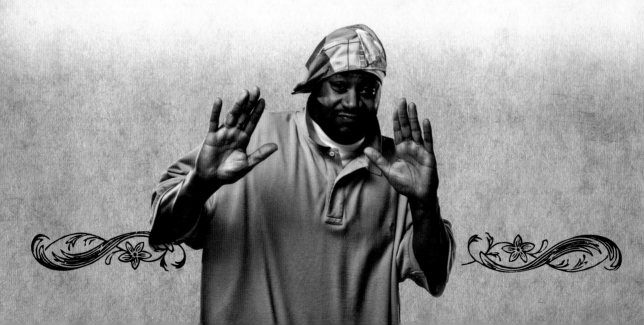

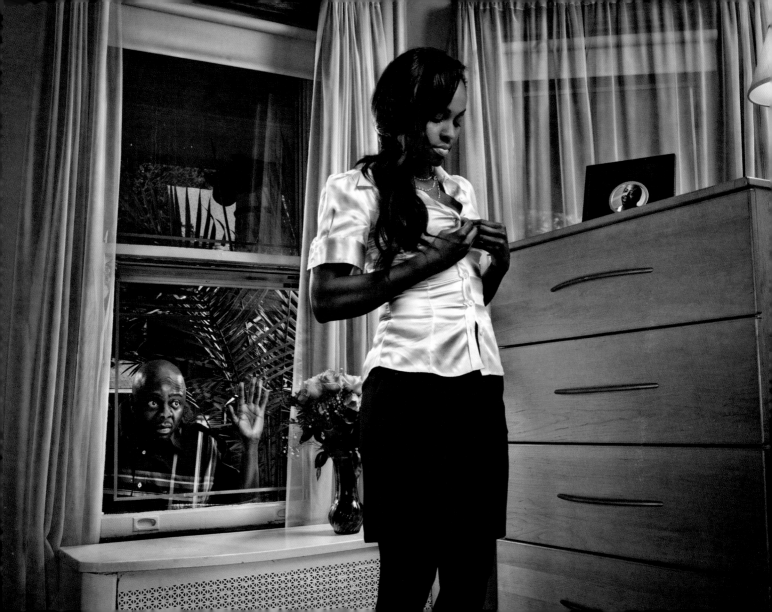

Pretty Toney says

SCREW A KEY YOU MIGHT FUCK
AROUND AND CATCH AN AXE. WHEN
THEY STOP LISTENING TO YOU AND
START TALKING SHIT. IT'S TIME TO GO.

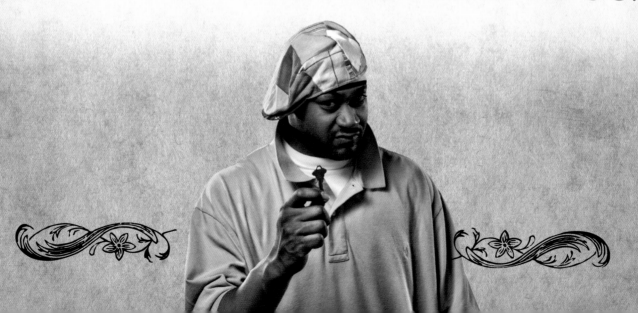

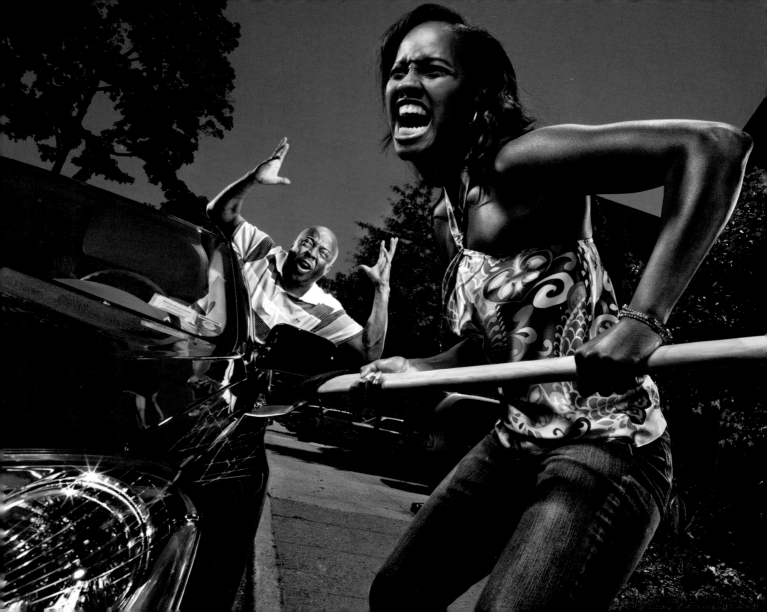

The World According To

Pretty Toney

CHAPTER IV

HUSTLER'S DIET

When you're running around in the streets it's almost impossible to find the time to eat properly. And since it's never a good idea to try to make moves on an empty stomach you probably find yourself eating any bullshit that happens to be around. The Hustler's Diet is your guide to fueling up in a tasty, healthy and cost effective way all the while you maintaining your grind.

Pretty Toney says

CLASSIC RAMEN

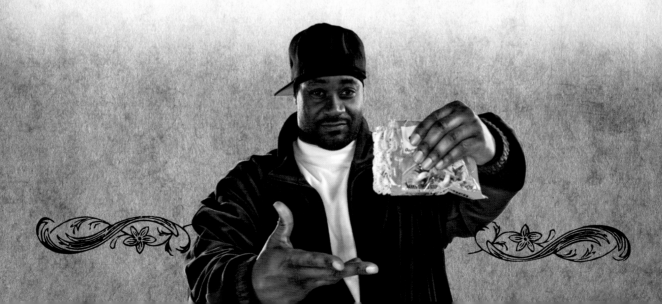

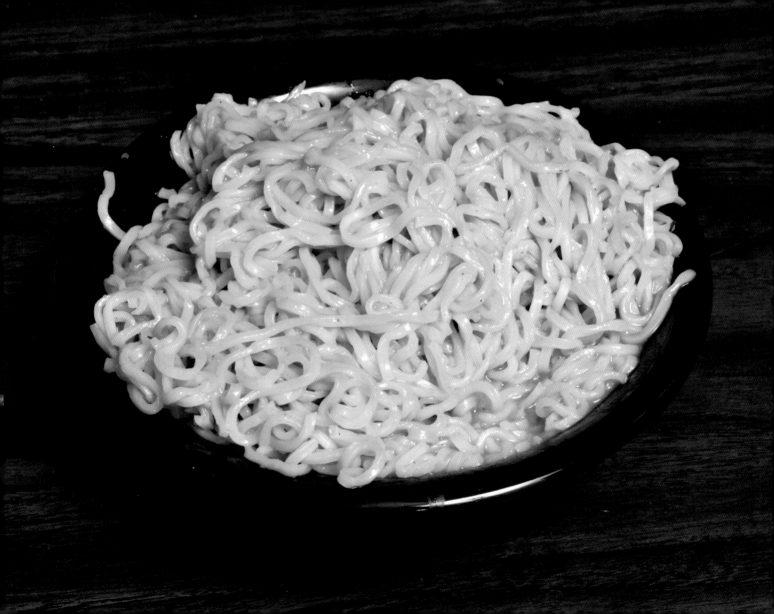

Pretty Toney says

RAMEN WITH
LOUIS RICH TURKEY

(gotta be Louis Rich)

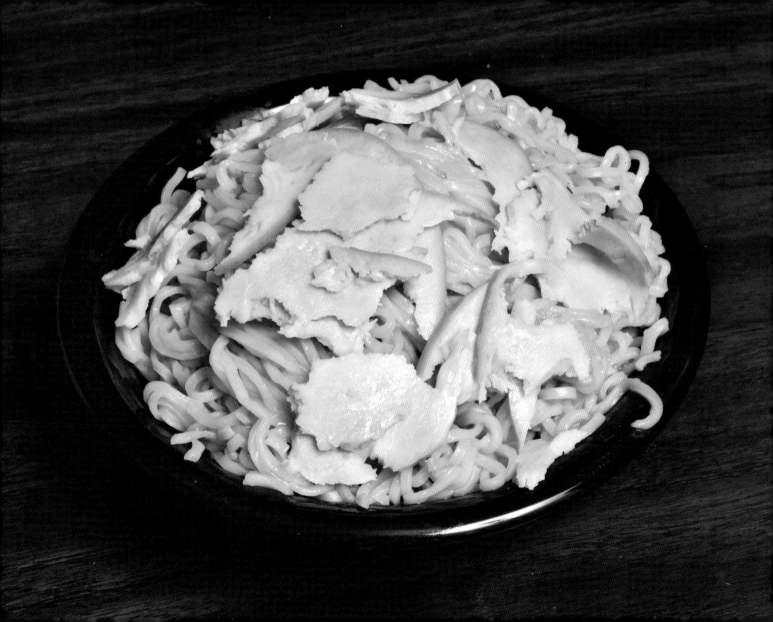

Pretty Toney says

RAMEN & CHEESE

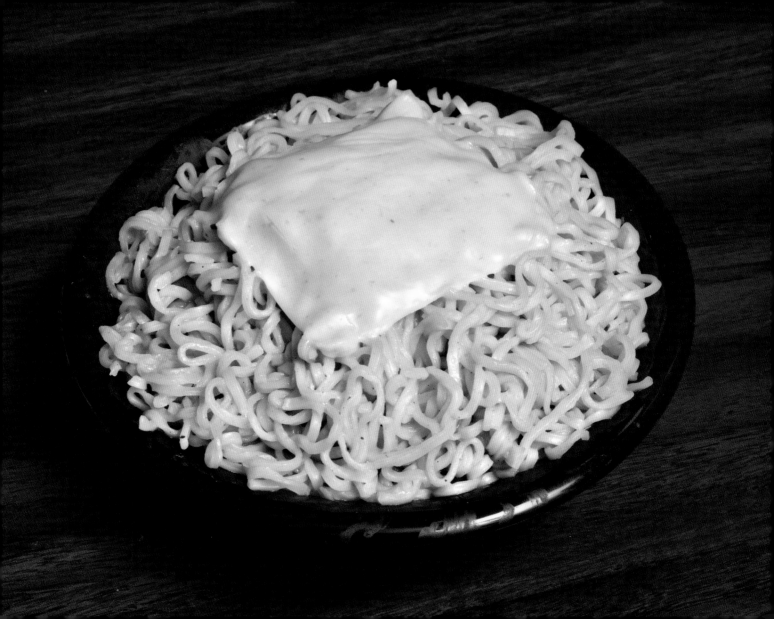

Pretty Toney says

RAMEN WITH
ROAST CHICKEN

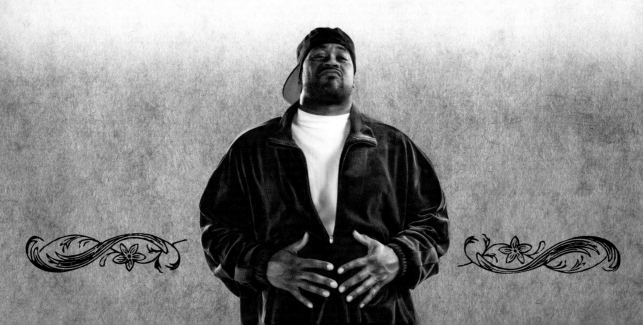

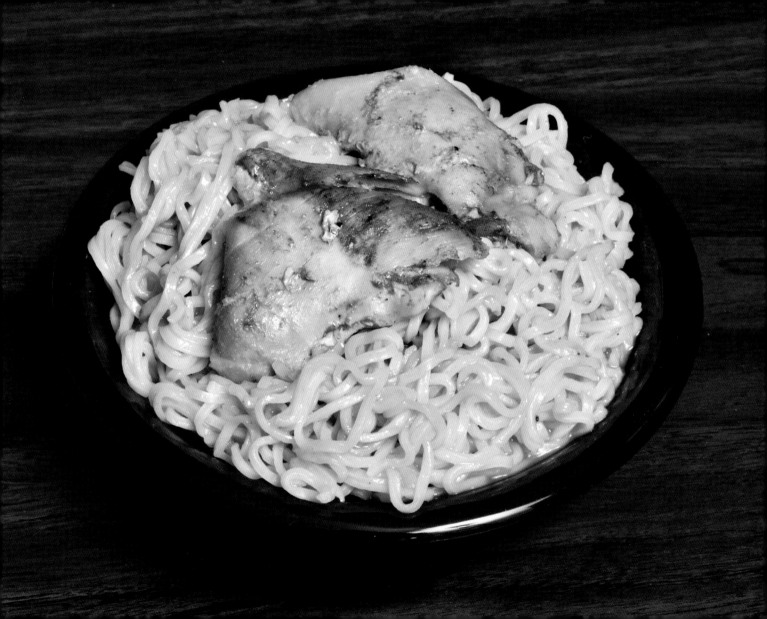

The World According To

Pretty Toney

TONEOLOGY

It's a crazy world out there. Nothing is the same as it used to be. Watermelon don't even have black seeds anymore. Applejacks taste different. Everything is cloned. Fuck your astrology, this is toneology.

Y'ALL SMART DUMB CATS NEED TO WISEN UP!

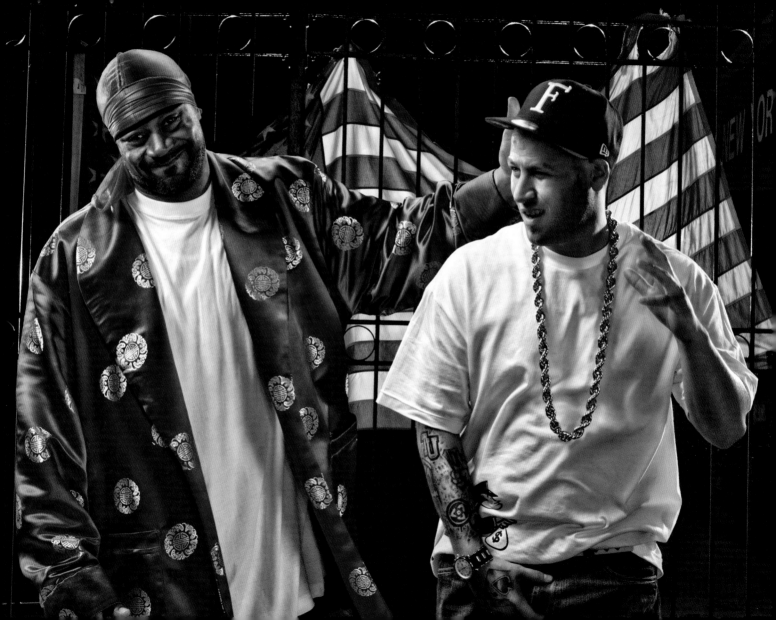

Pretty Toney says

SHIT IS FUCKED UP CAUSE FAMILIES
DON'T EAT TOGETHER ANYMORE.
A LACK OF COMMUNICATION LEADS
TO BAD UNDERSTANDING.

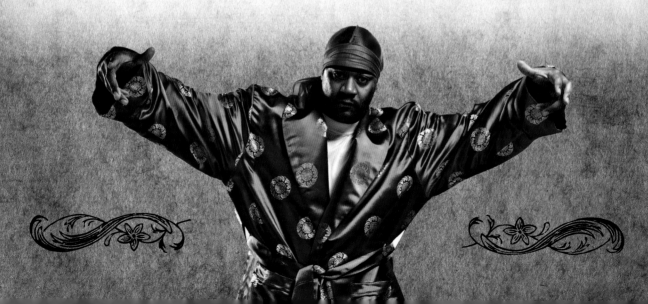

Pretty Toney says

DON'T LET A MUTHAFUCKA KISS
YOUR BABY! YOU DON'T KNOW
WHERE HE'S BEEN.

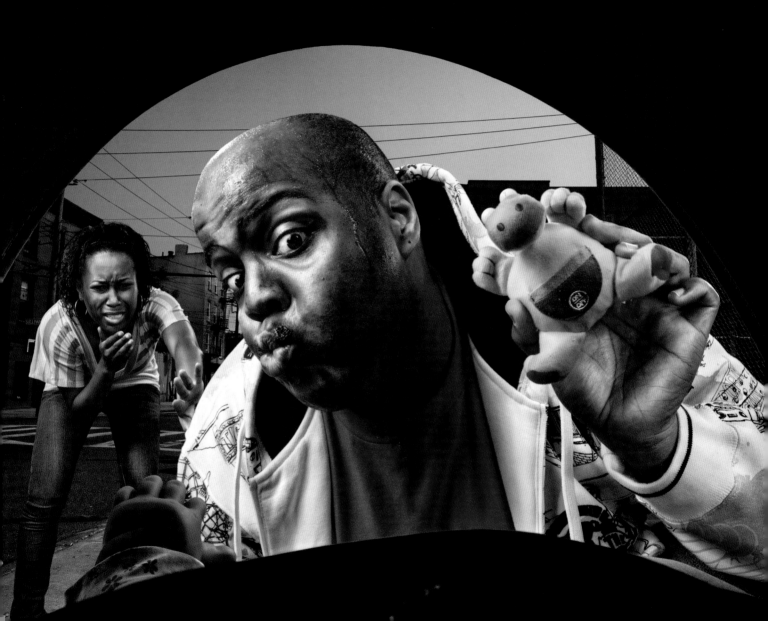

Pretty Toney says

WE TURNED MOTHER EARTH OUT.

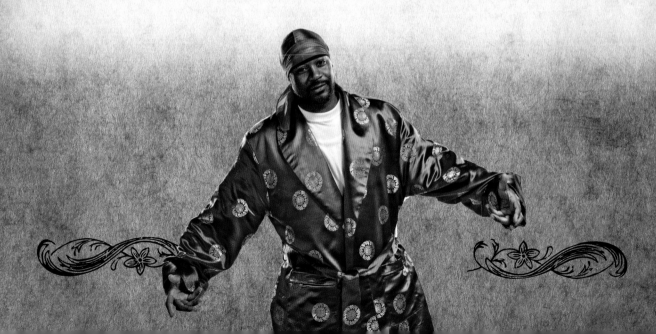

Pretty Toney says

THE CHAMP: ONE WHO WINS!

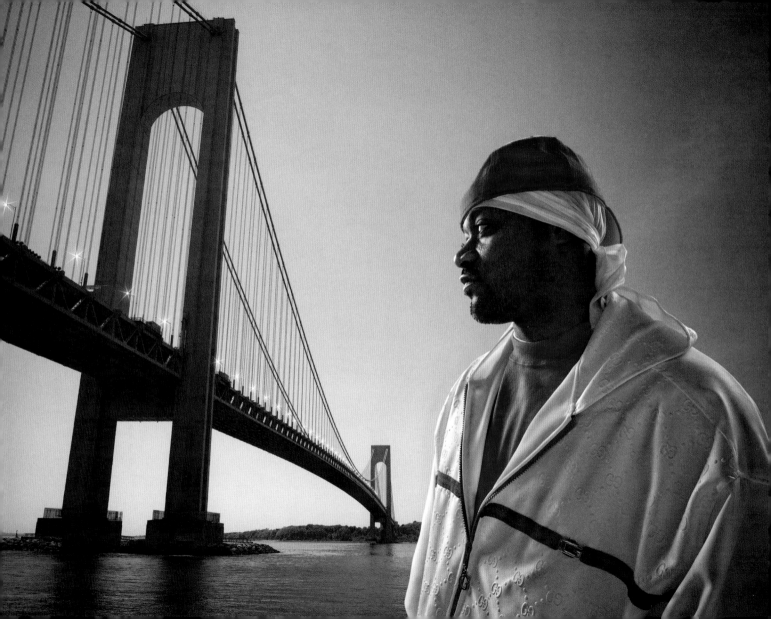

Pretty Toney says

HEAVY HEAD MOTHERFUCKERS—IF YOU CAN'T HANDLE YOUR LIQUOR, DON'T DRINK!

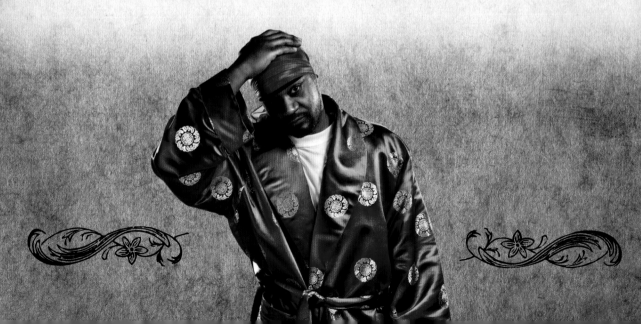

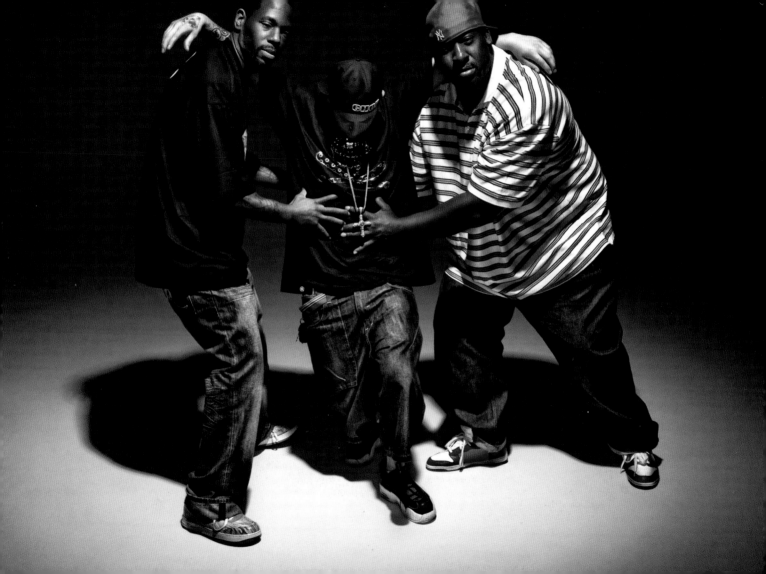

Pretty Toney says

KID WITH THE MOST KNOWLEDGE WILL OBTAIN TO TOUCH TOP DOLLARS.

~ *"Ghost Deini", 1st verse, Supreme Clientele*

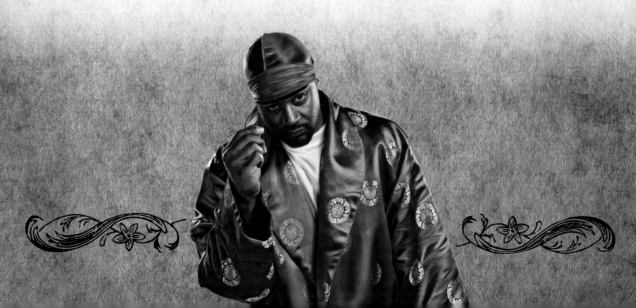

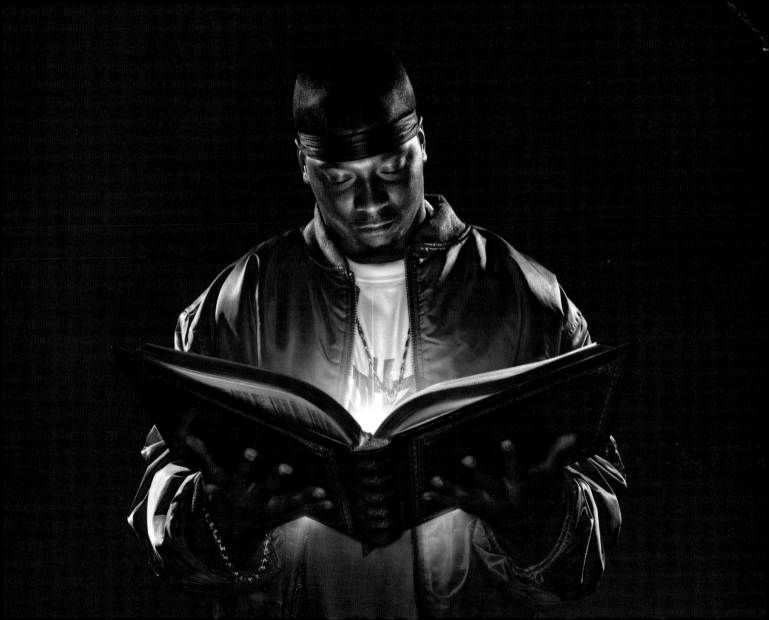

Pretty Toney says

DON'T FEAR DEATH!
WHAT WE GO THROUGH HERE
ON EARTH IS ONLY A TRIAL.

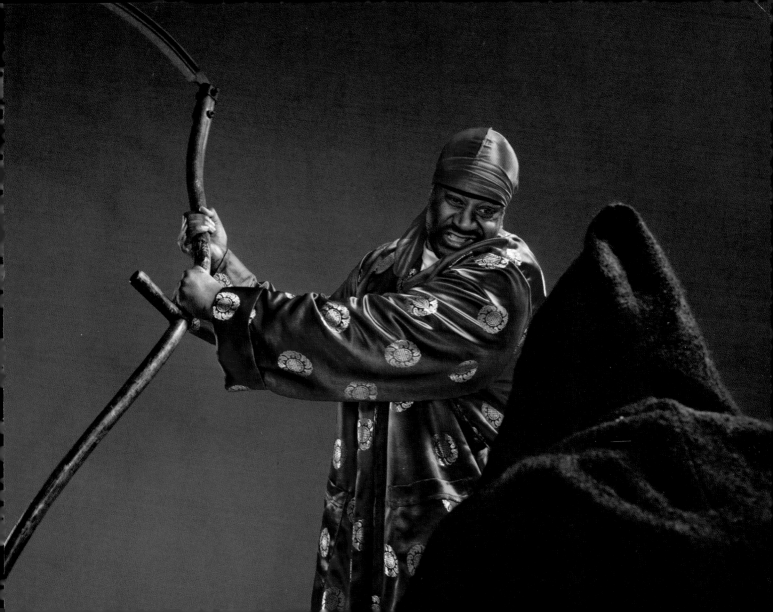

Author Bio . . .

INSPIRED BY THE CLASSIC SKITS ON GHOSTFACE'S ALBUMS, AND GHOST'S ALTER EGO PRETTY TONEY, MTV PROMOS WRITER/DIRECTOR AND FELLOW NEW YORKER J. BRIGHTLY APPROACHED THE STATEN ISLAND MC ABOUT BRINGING SKITS TO TELEVISION AND THE INTERNET.

FEELING THE NEED TO BLESS THE WORLD WITH MORE JEWELS CONCERNING LIFE, LOVE AND HUSTLING GHOSTFACE AND J. BRIGHTLY SAT DOWN TOGETHER OVER THE COURSE OF 8 MONTHS AND CRAFTED THE MANUAL TO HAPPY AND SUCCESSFUL LIVING KNOWN AS "THE WORLD ACCORDING TO PRETTY TONEY."

Special Thanks To . . .

JODI LAHAYE, MIKE CARUSO AND MONEY COMES FIRST, LISA PRESTON, KEVIN MACKALL, JACOB HOYE, AMY CAMPBELL, BRENT STOLLER, LOLLION CHONG, DONNELL RAWLINGS, THE THEODORE UNIT, KEVIN DAWKINS

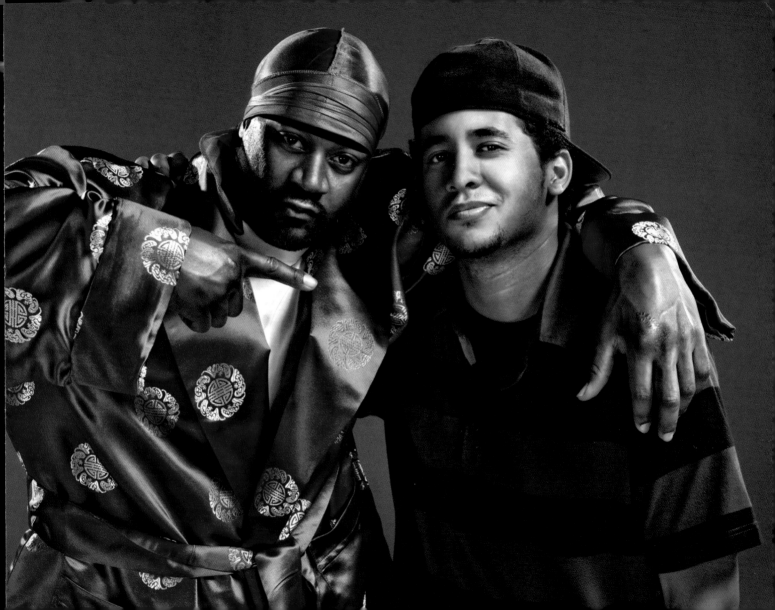